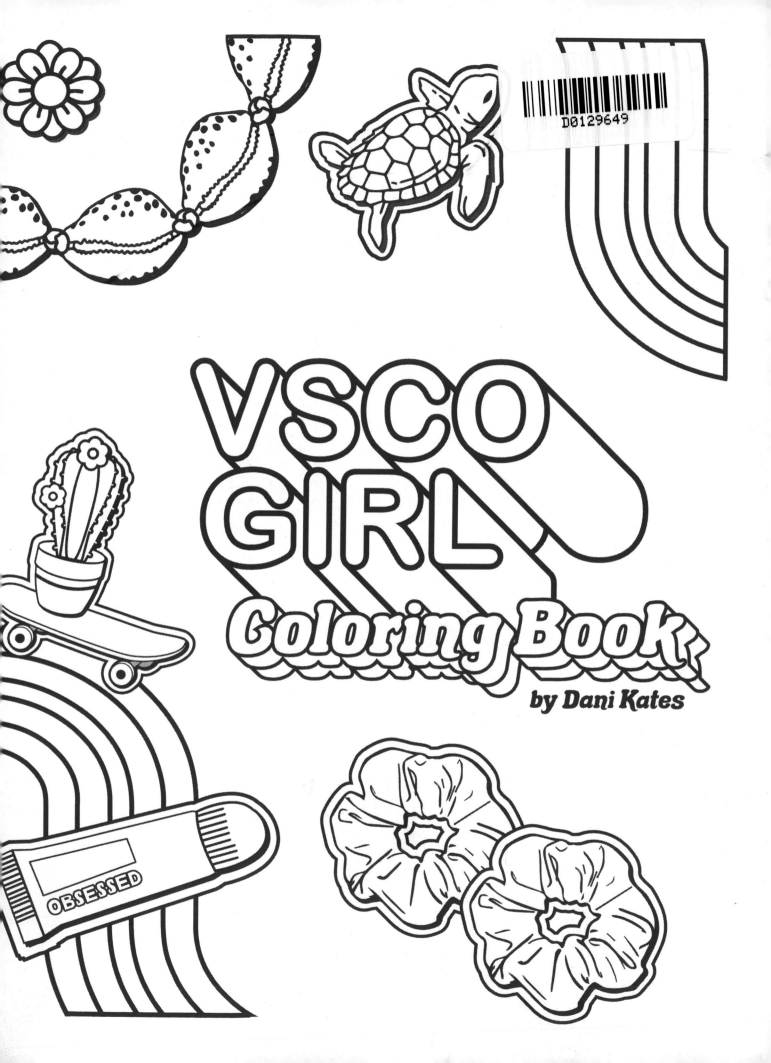

VSCO GIRL
Coloring Book
by Dani Kates

OBSESSED

SHARE YOUR ART!

Use
#VscoArt
#VscoGirlColoringBook

Follow & Tag
@DaniKatesColoring

Visit
www.DaniKates.com

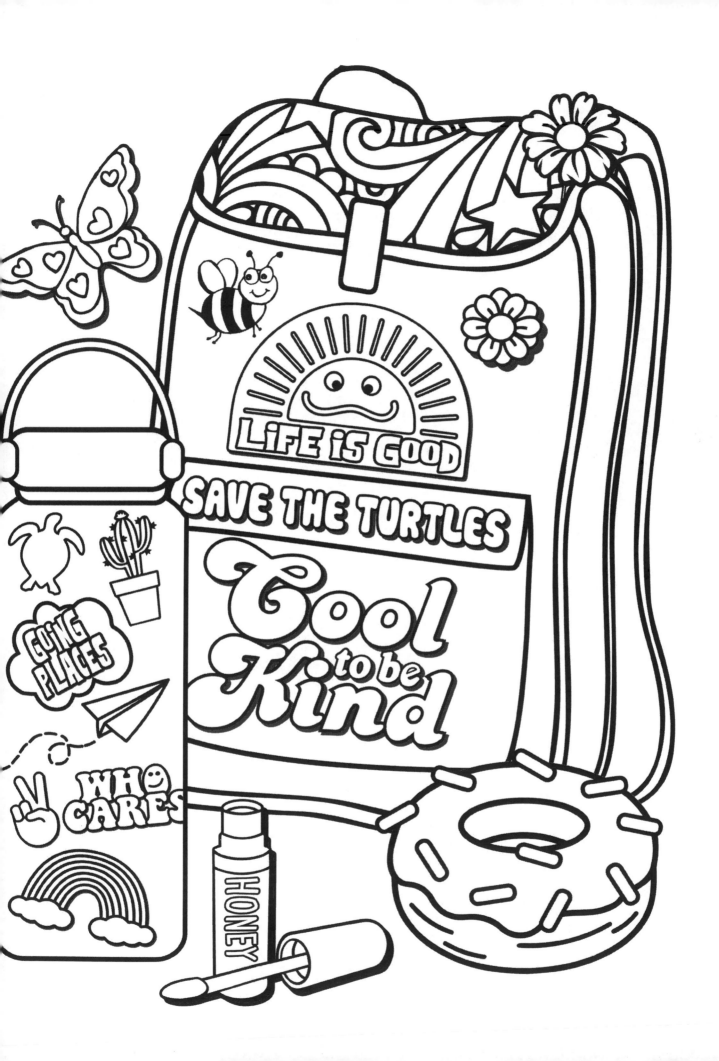

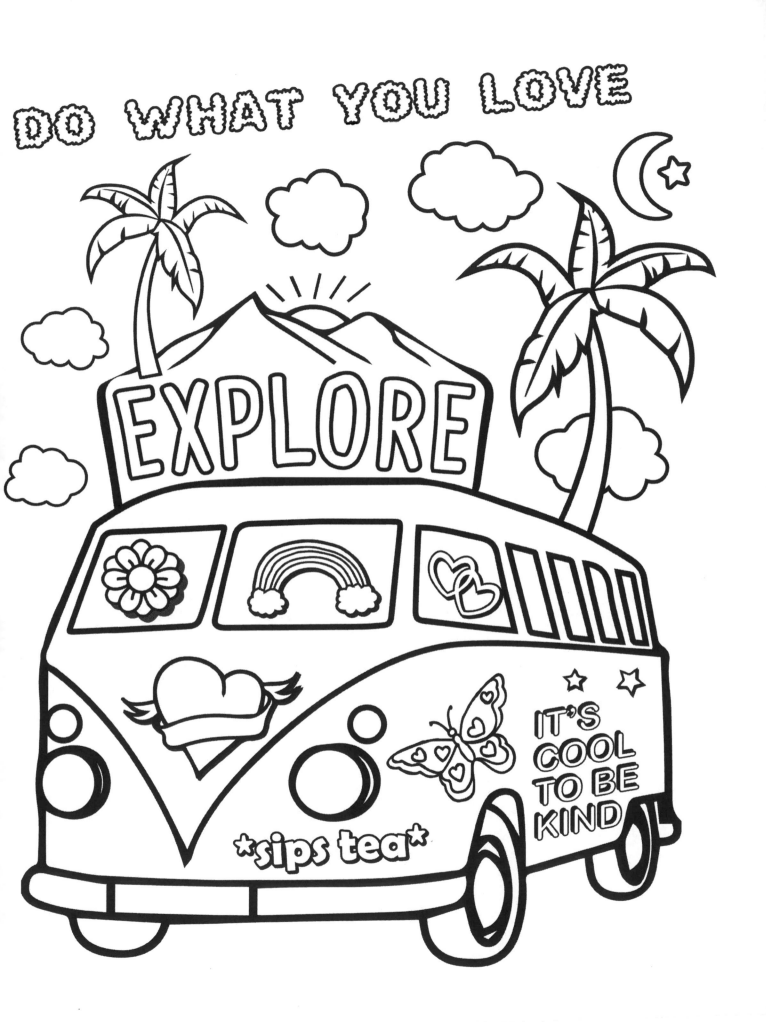

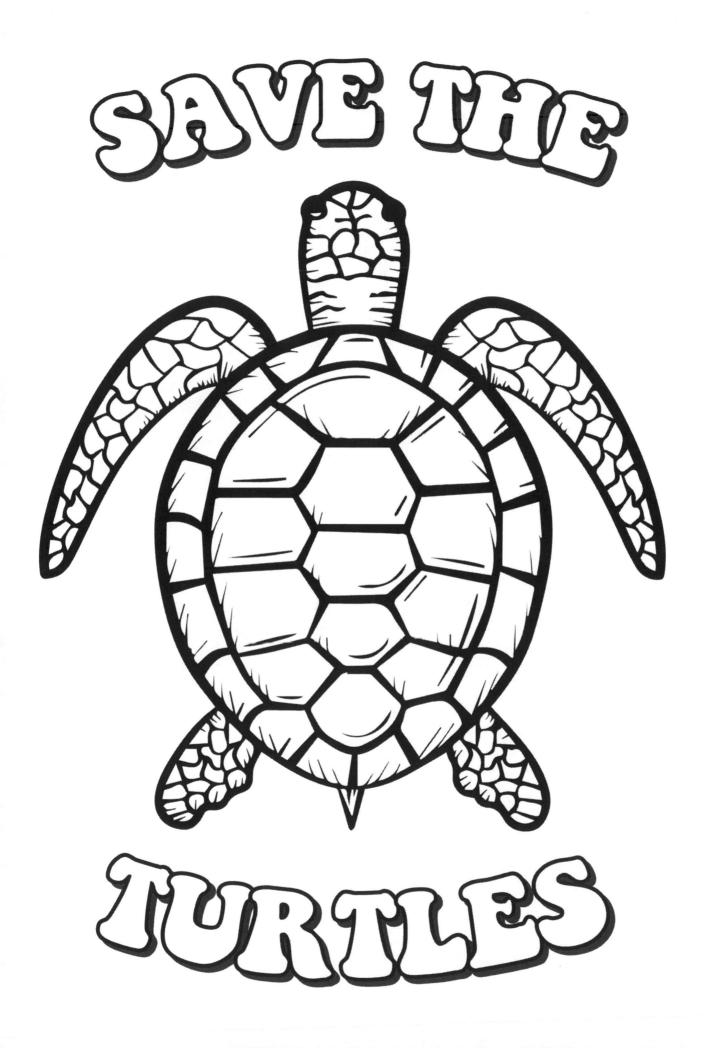

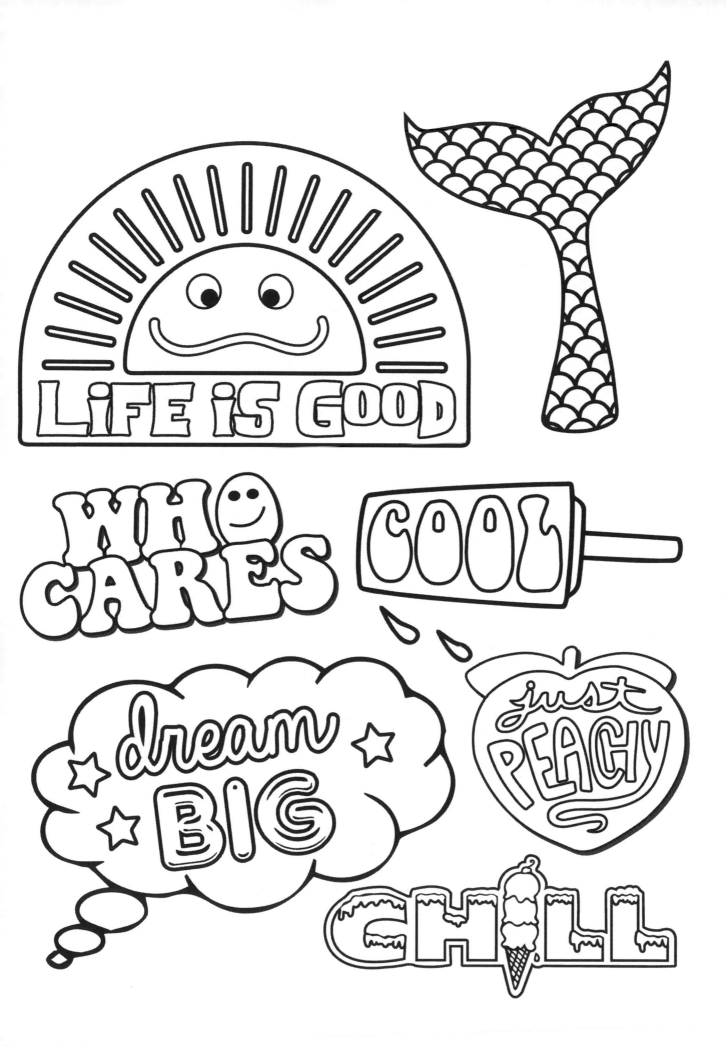

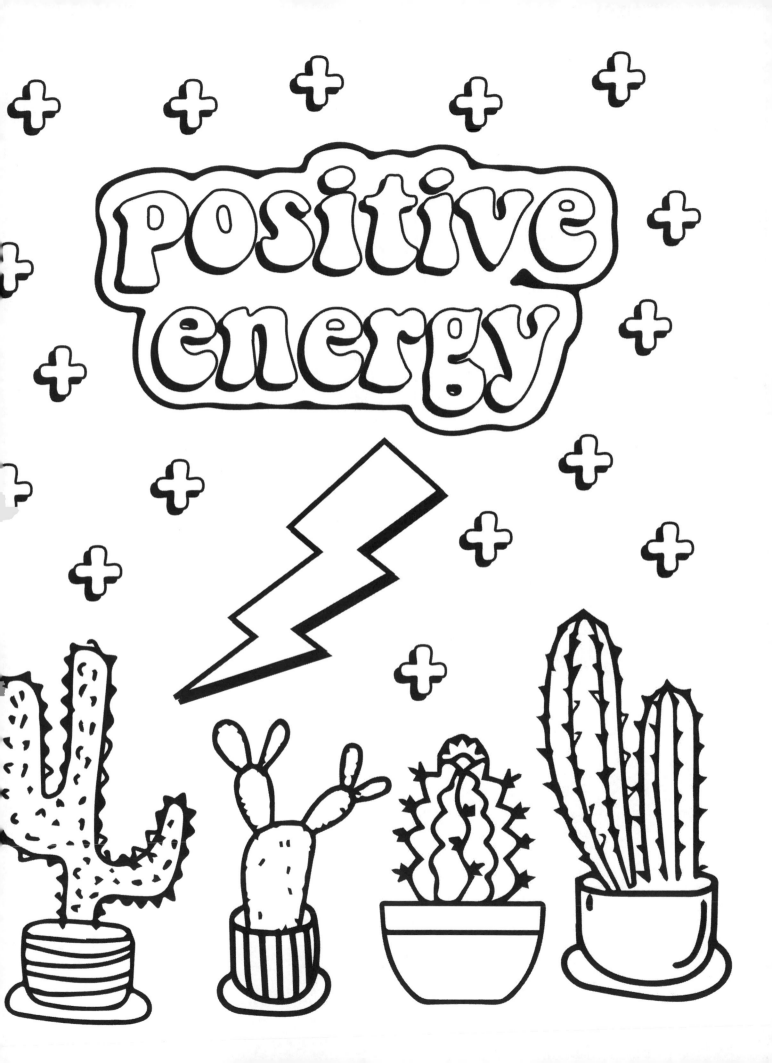

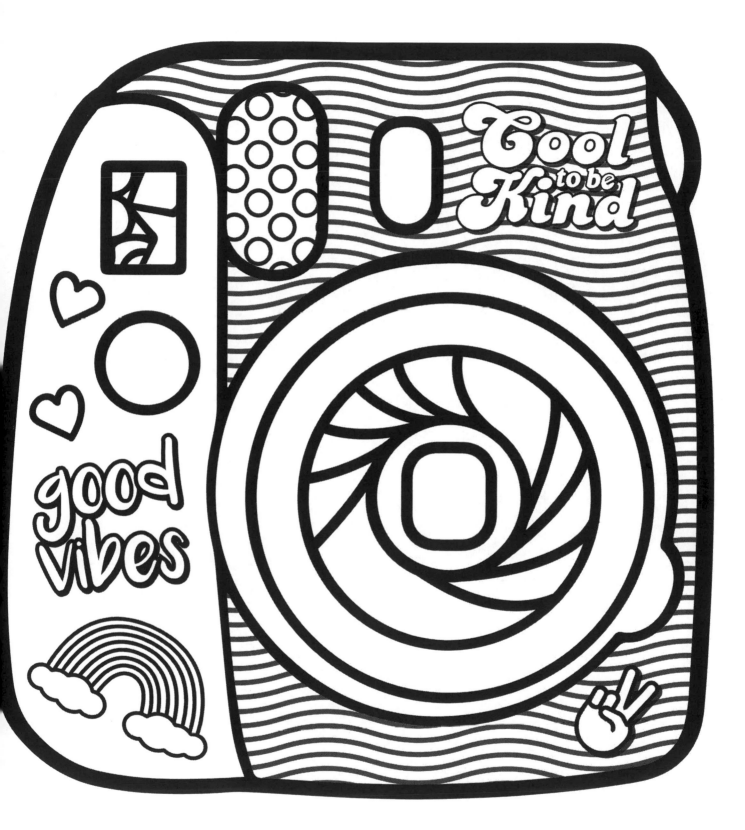

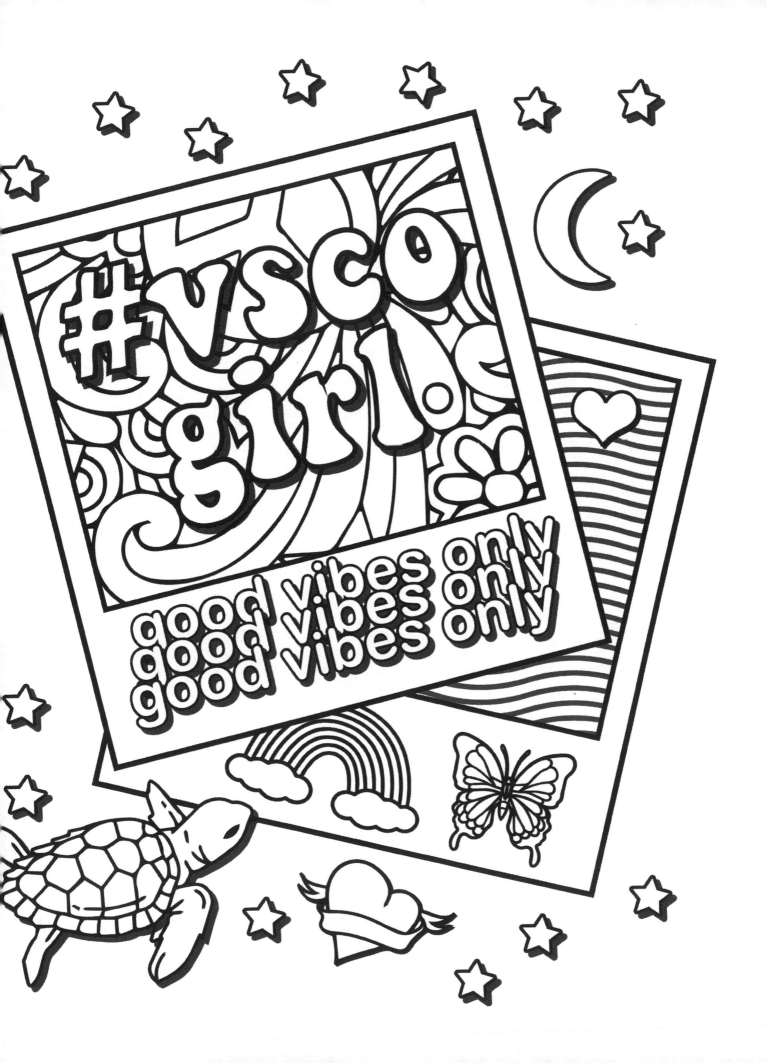

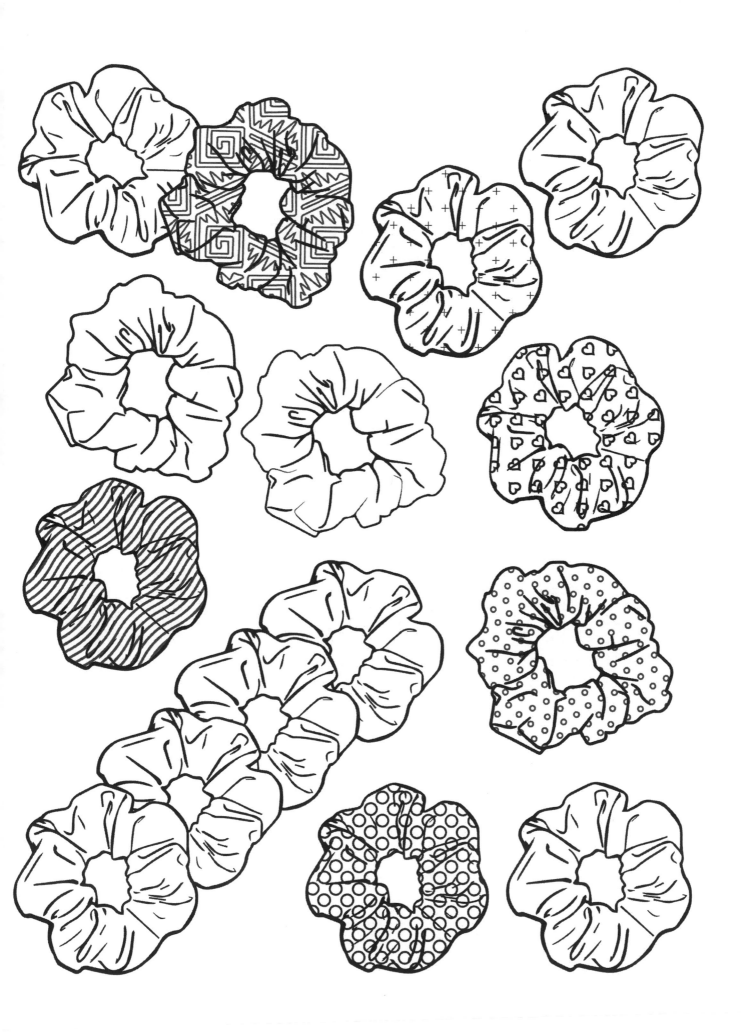

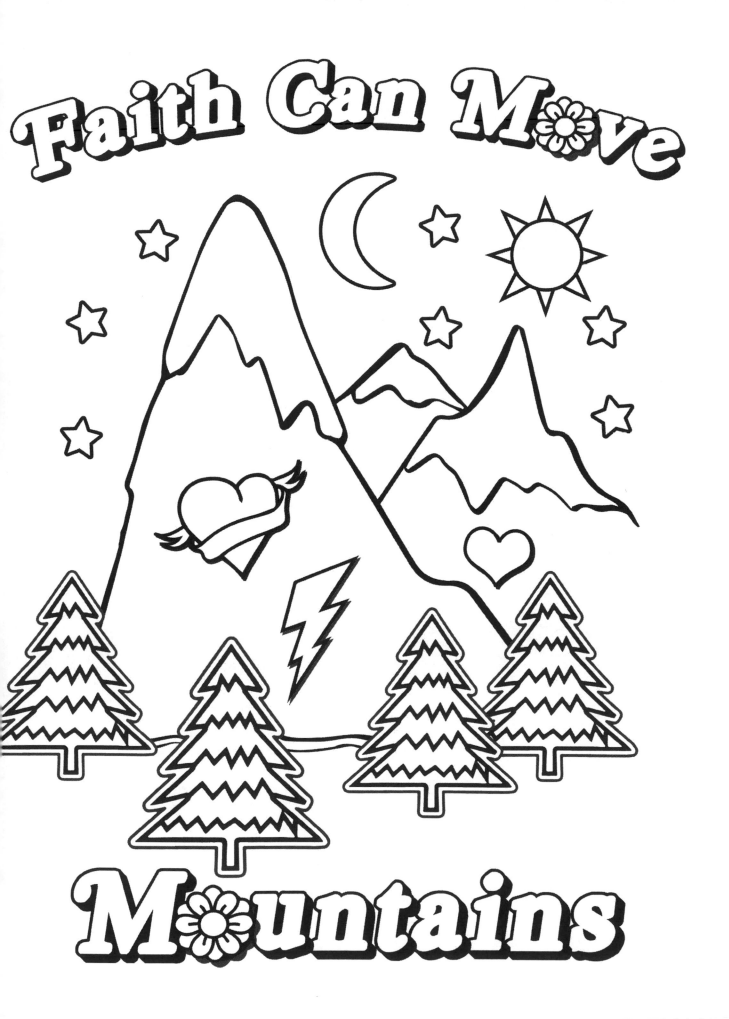

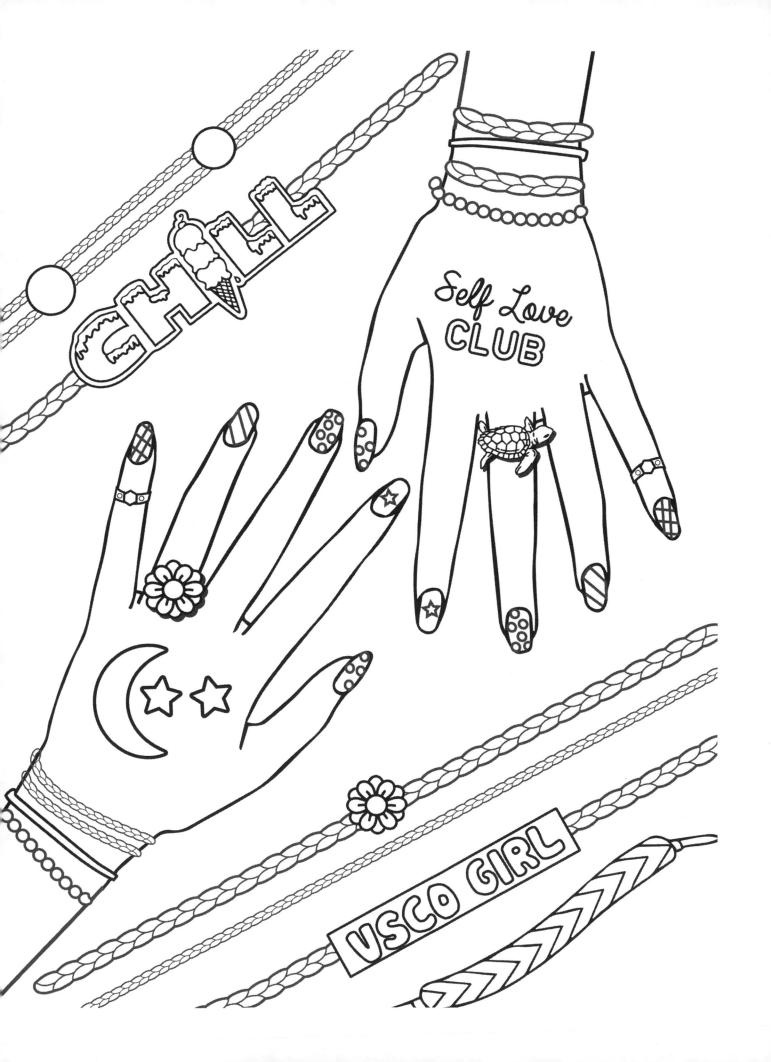

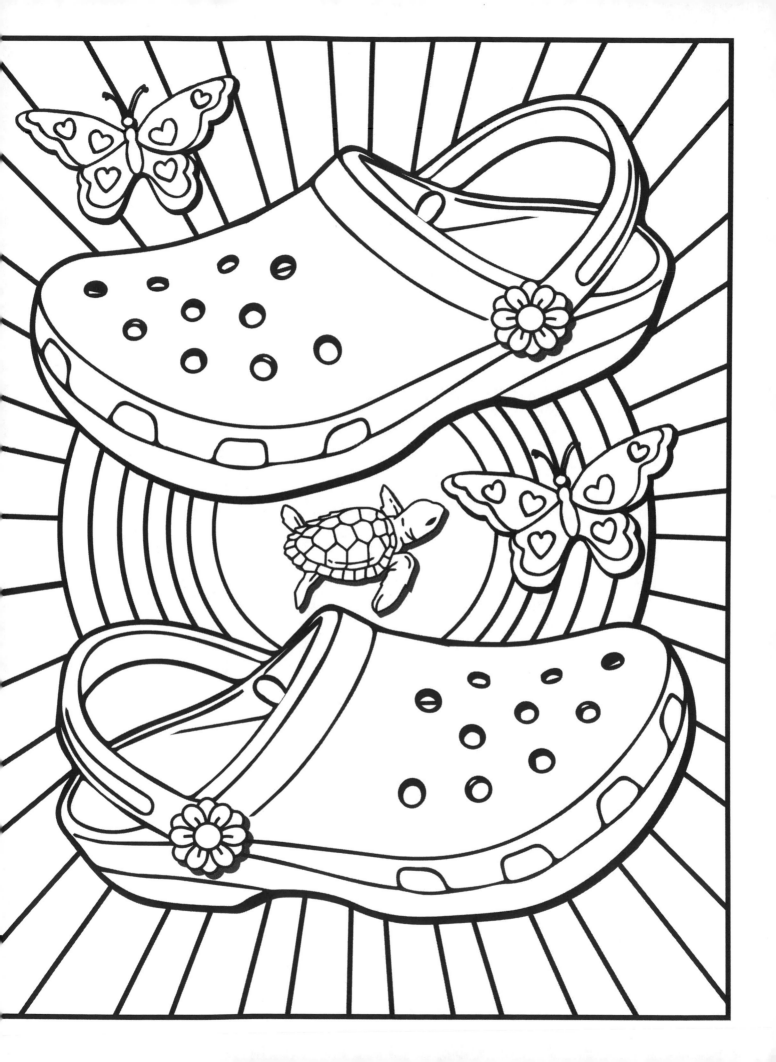

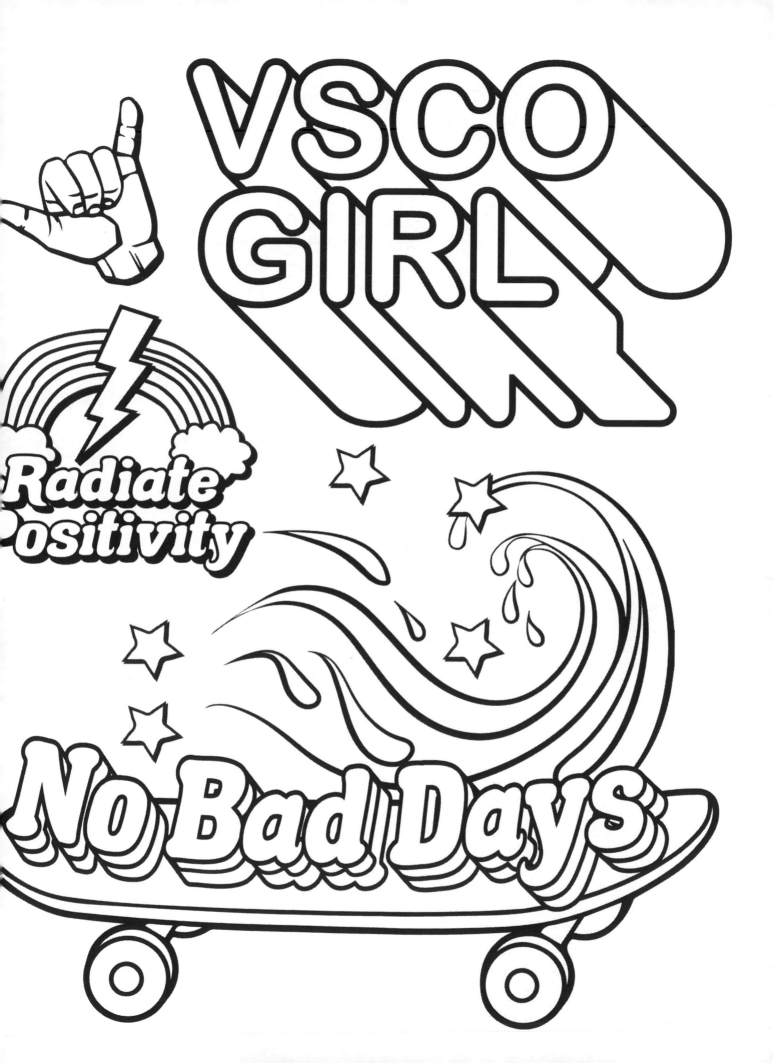

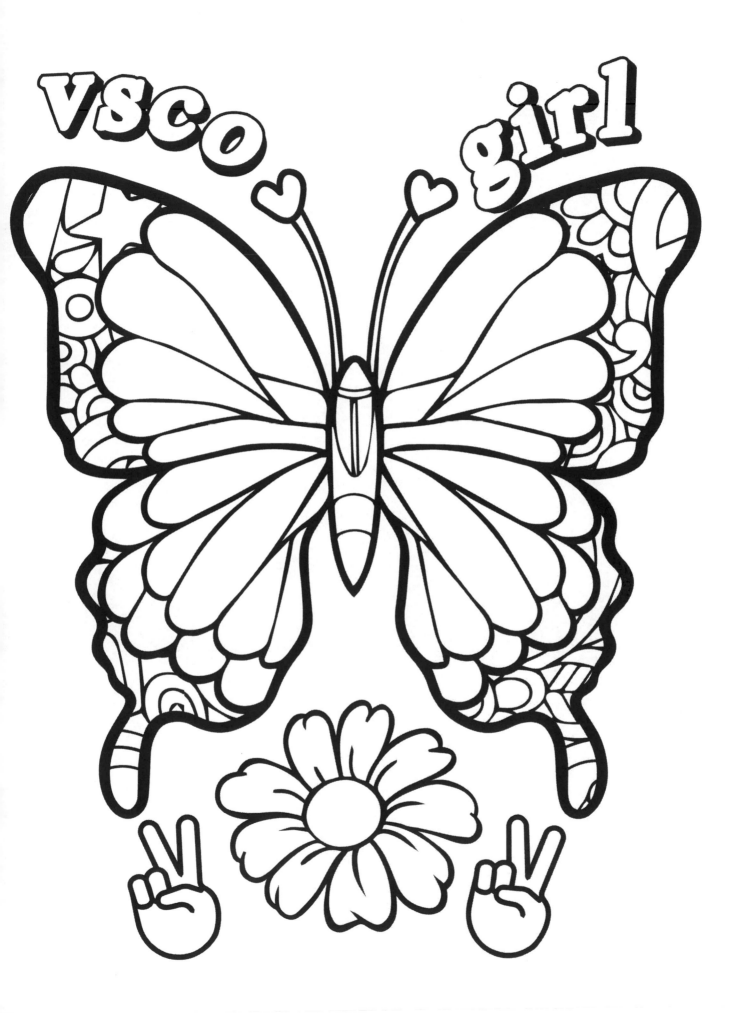

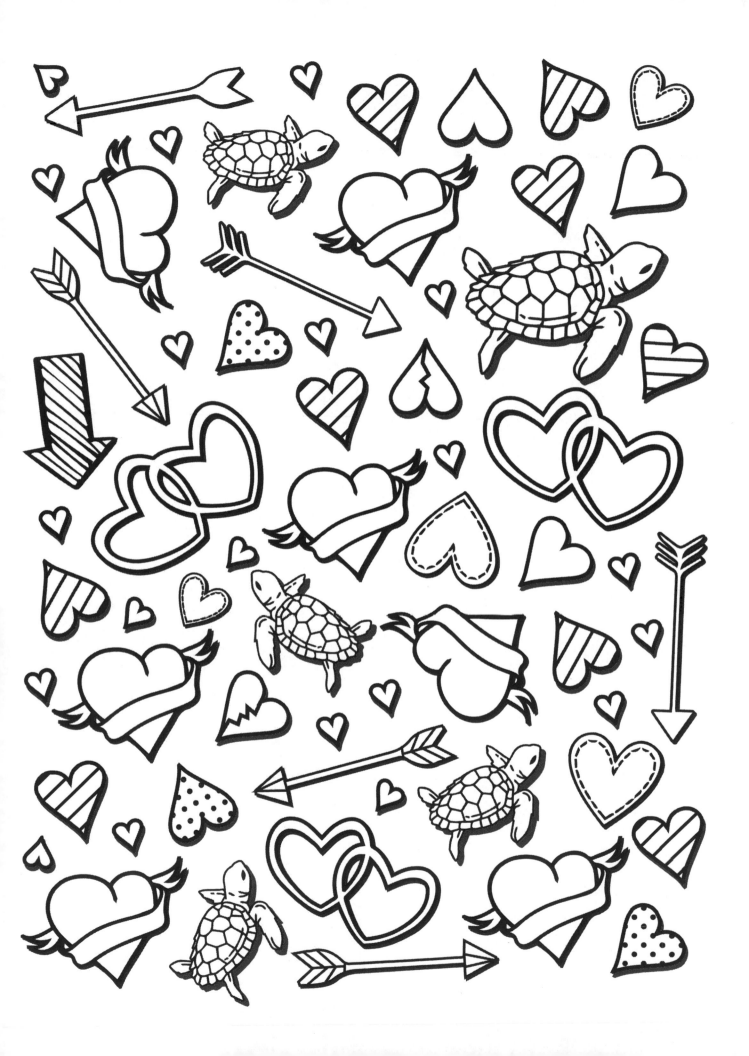

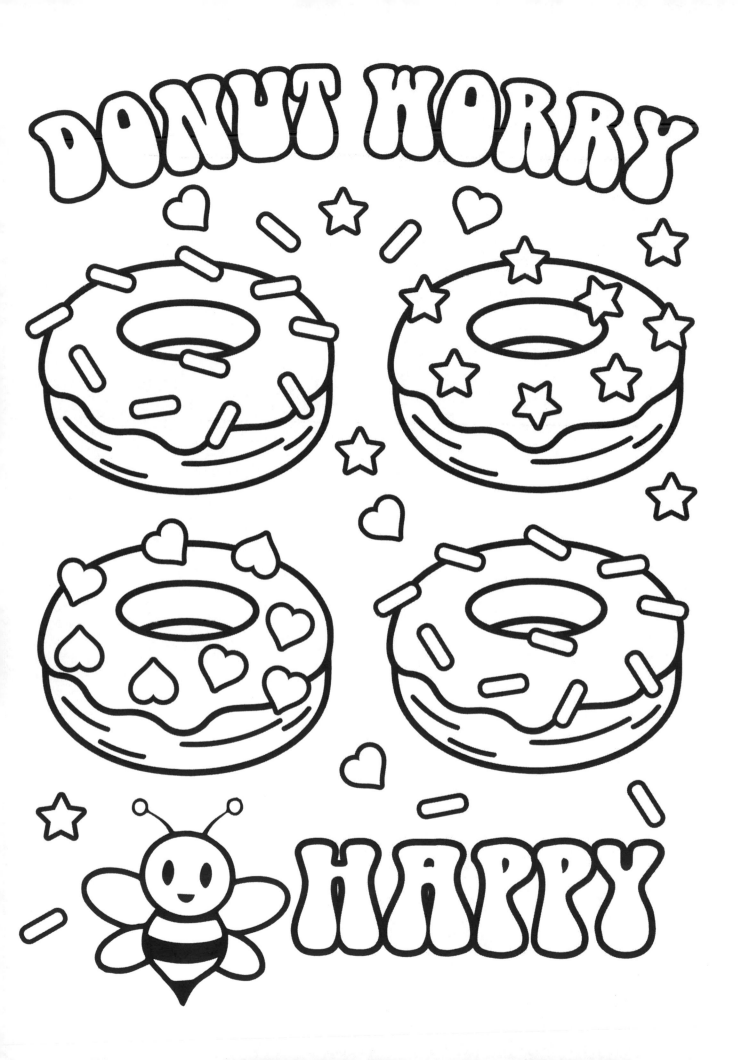

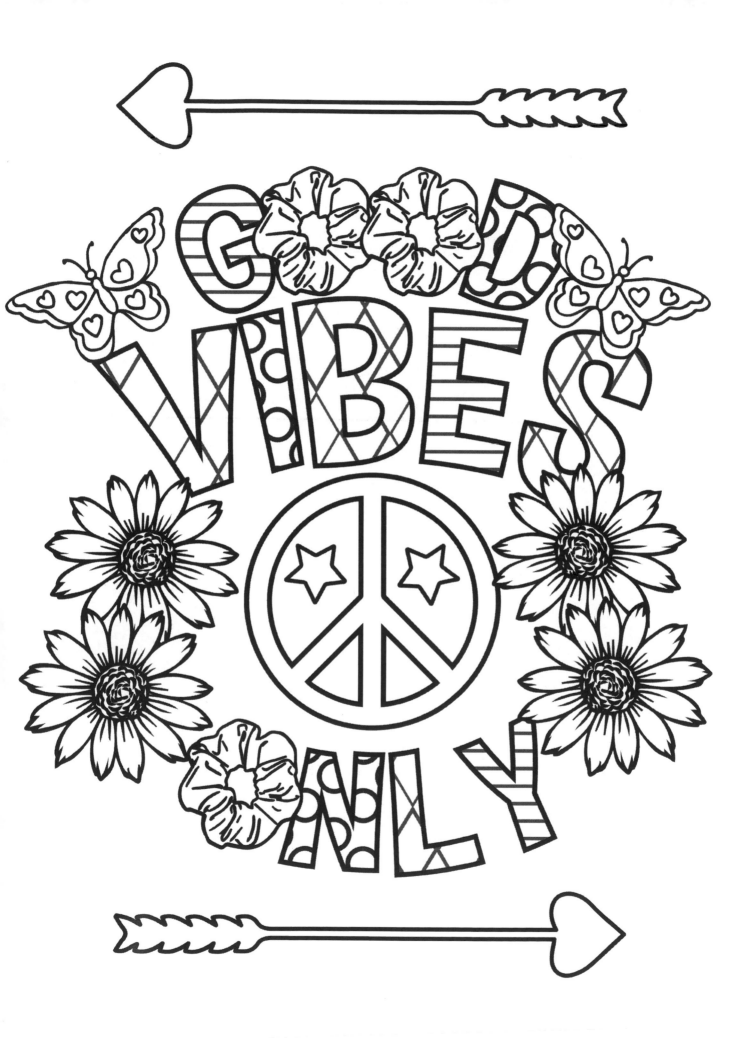

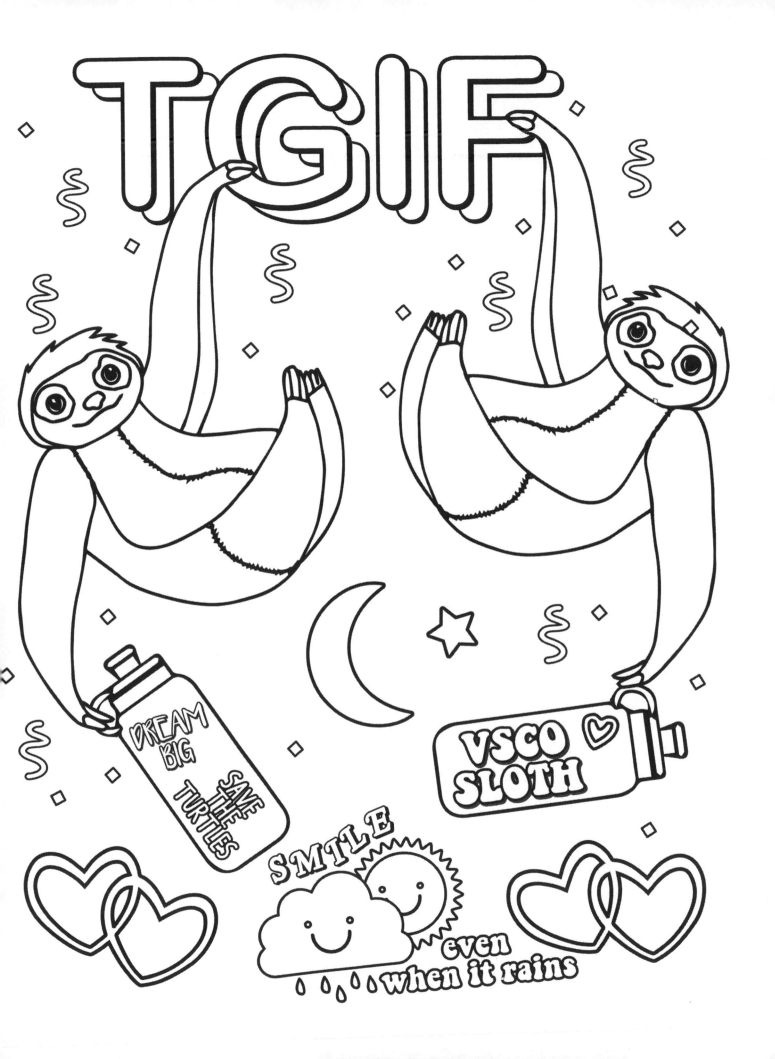

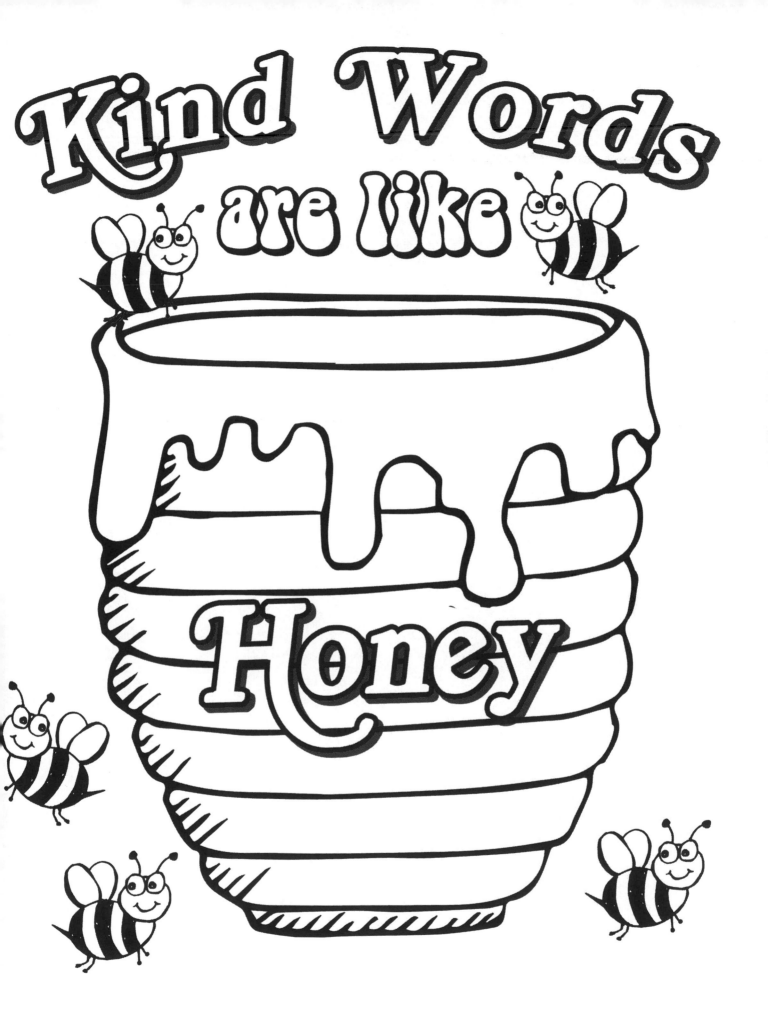

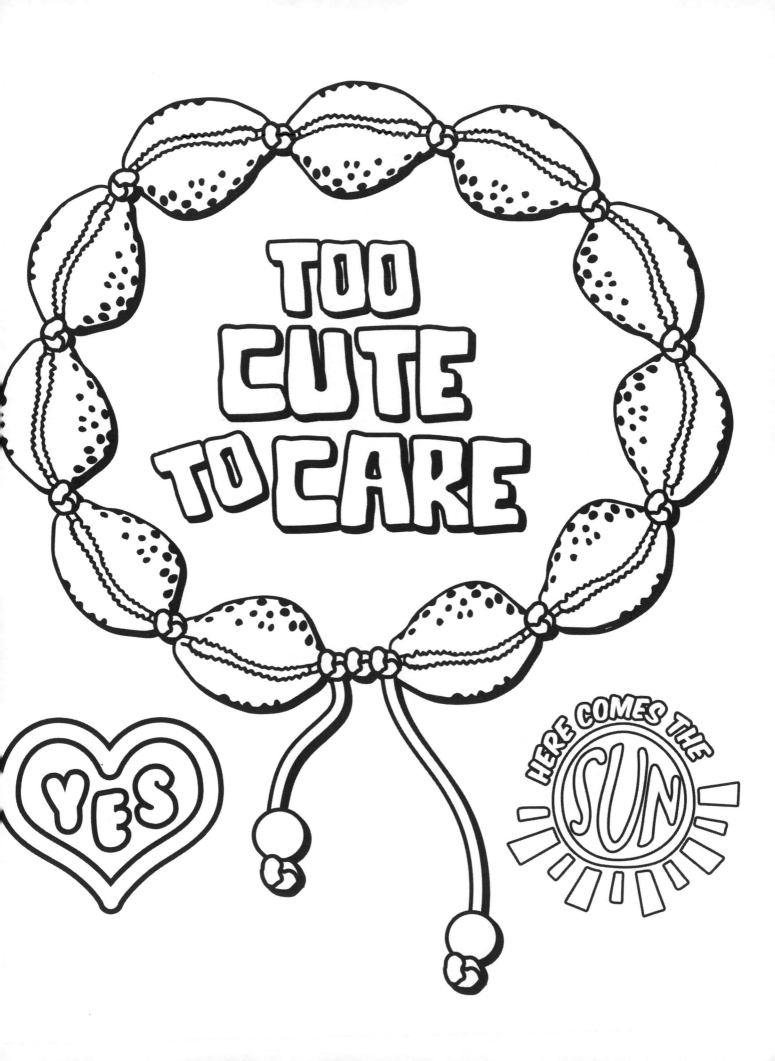

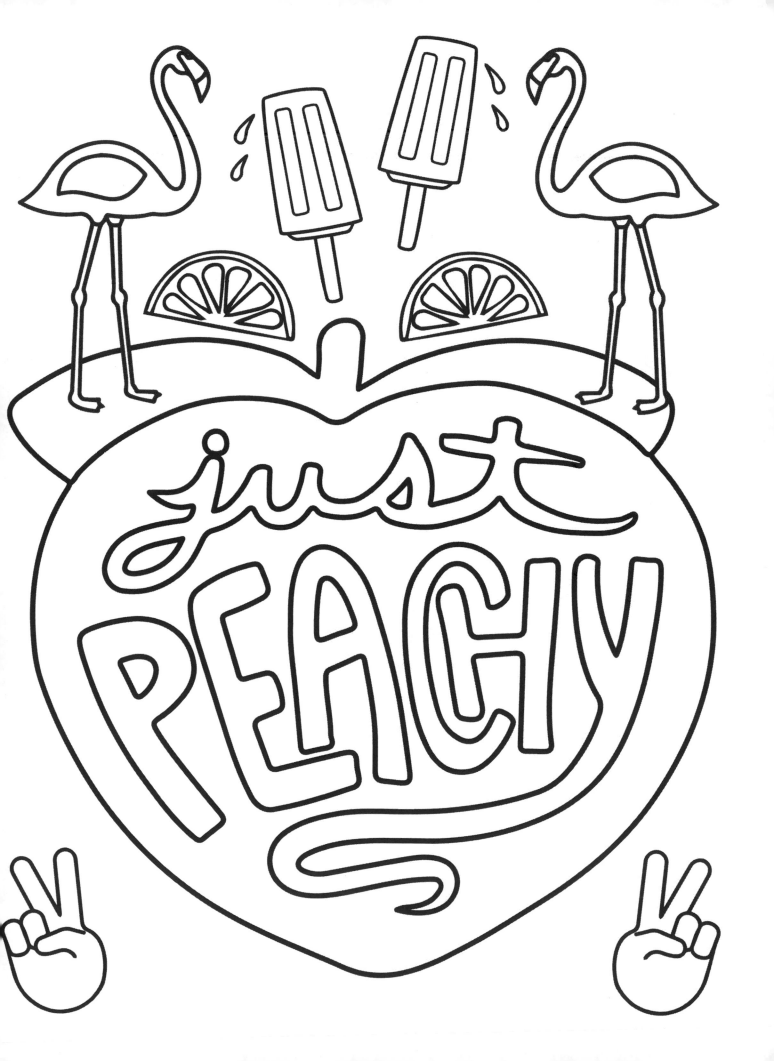

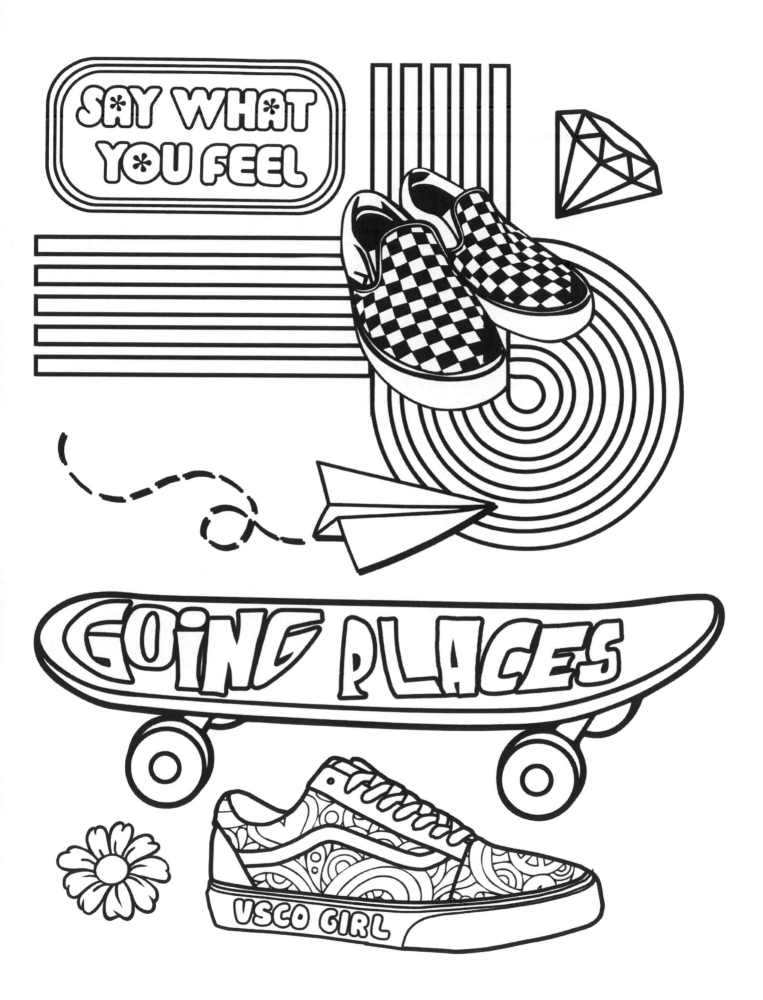

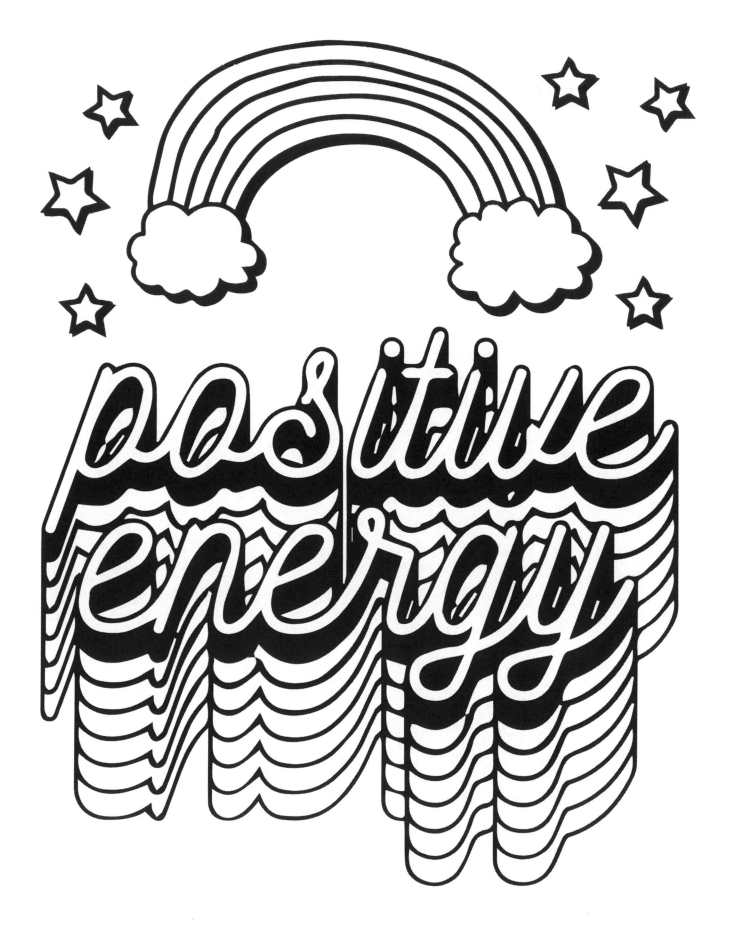

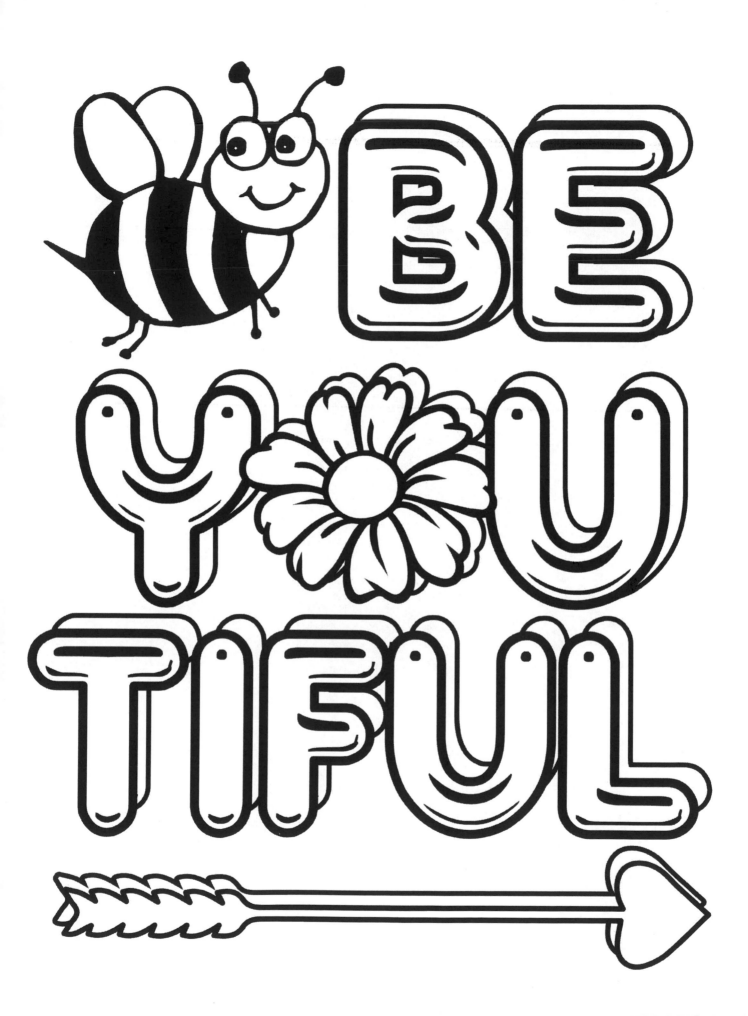

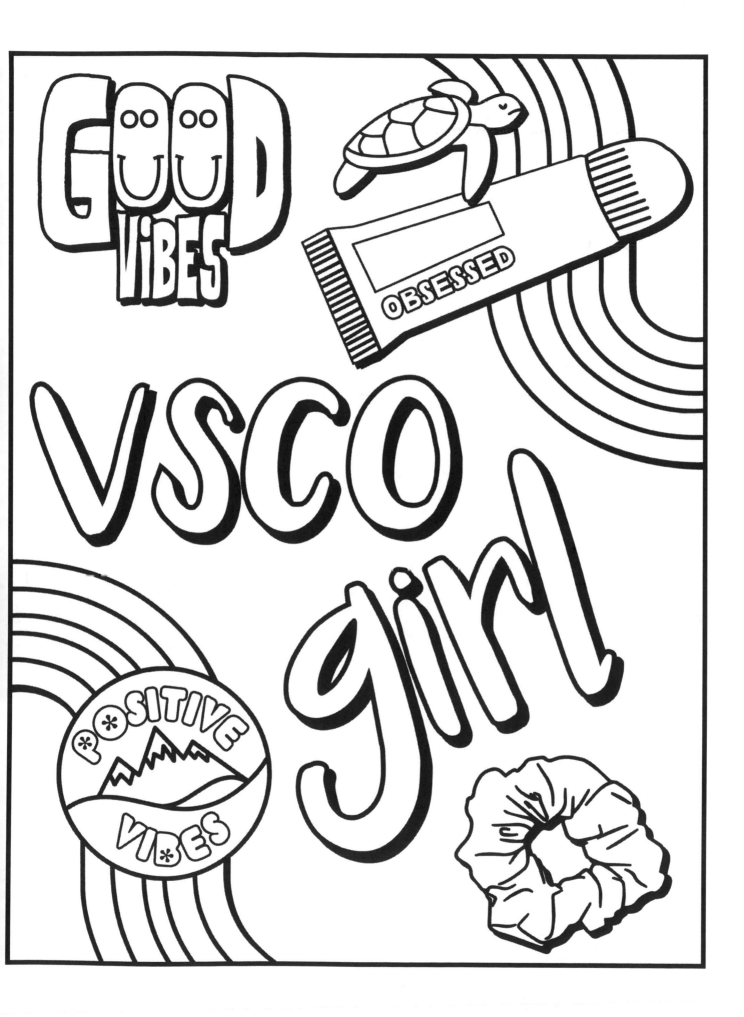

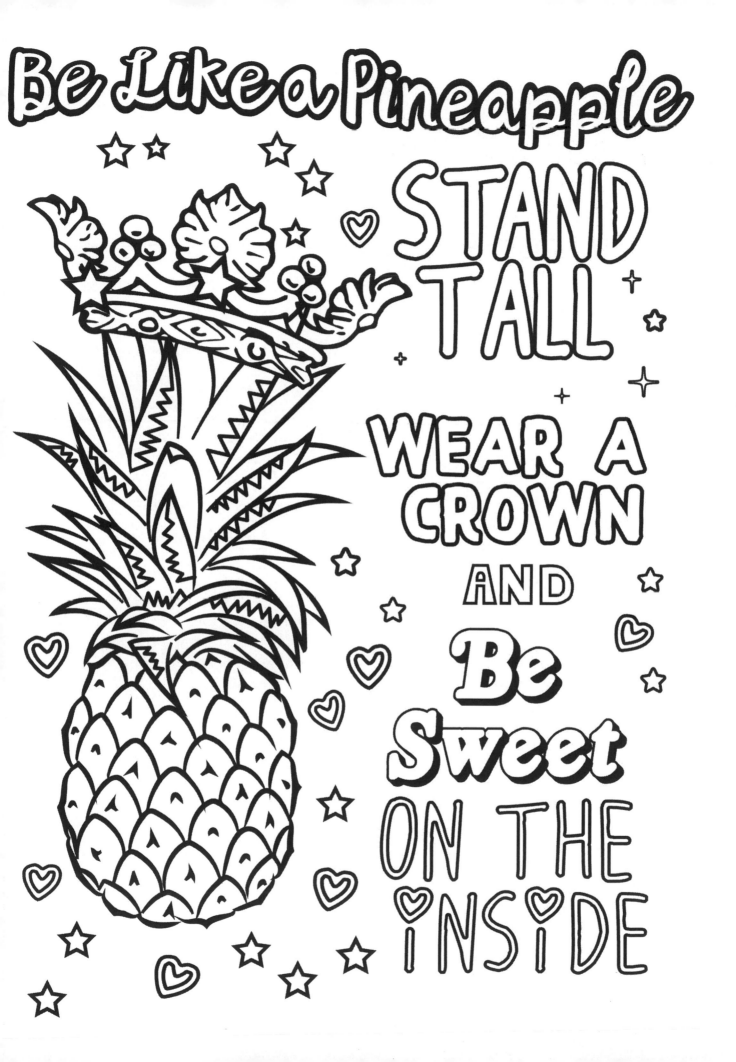

Made in the USA
San Bernardino, CA
08 January 2020